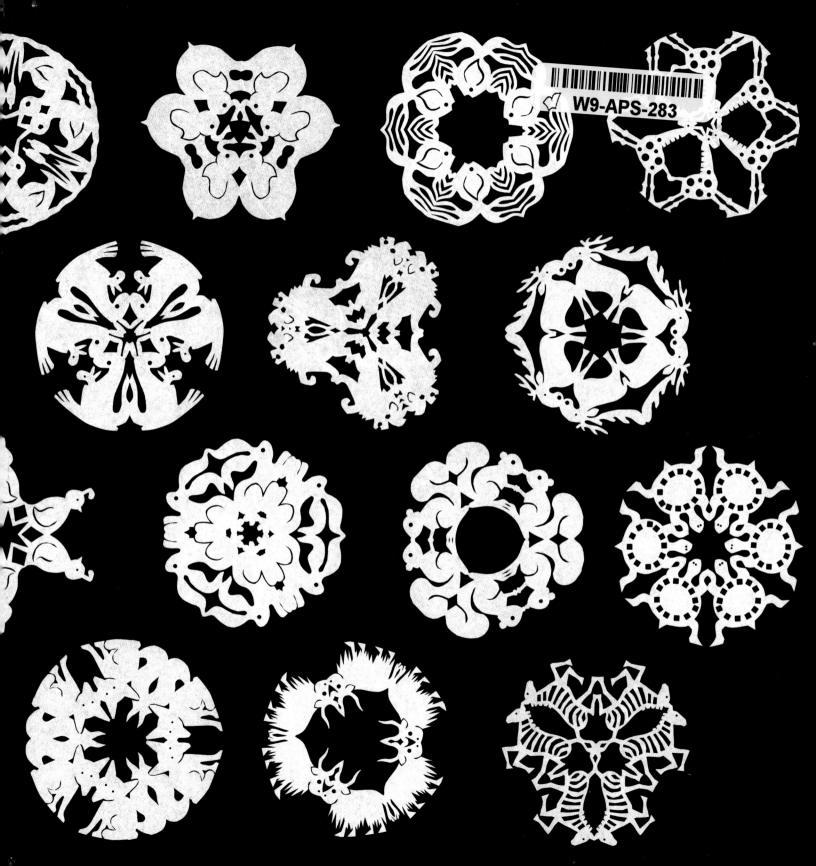

ZOO FLAKES ABC

WILL C. HOWELL

WALKER & COMPANY NEW YORK

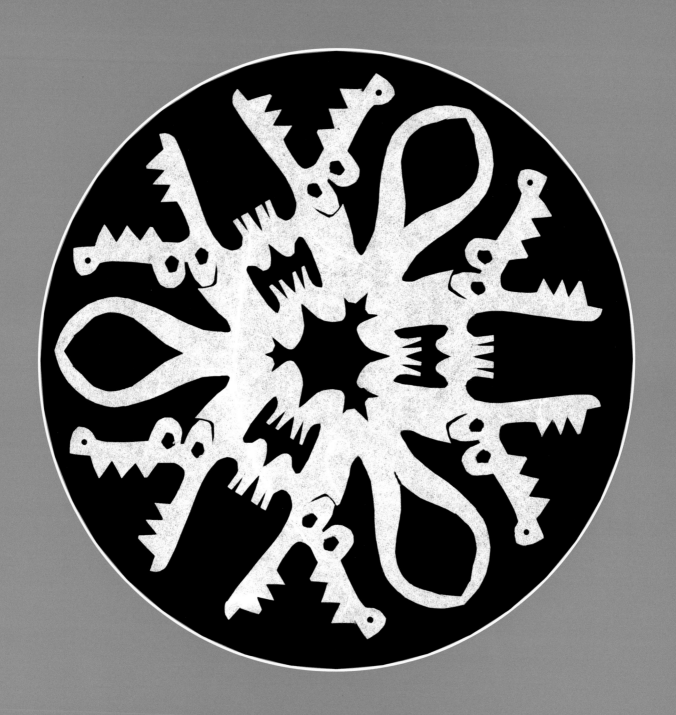

A is for Alligator

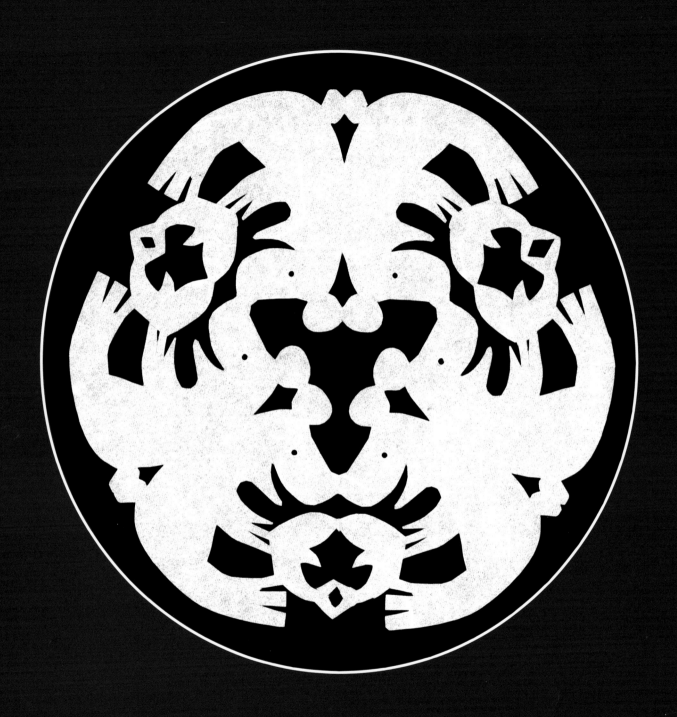

B is for BEAR

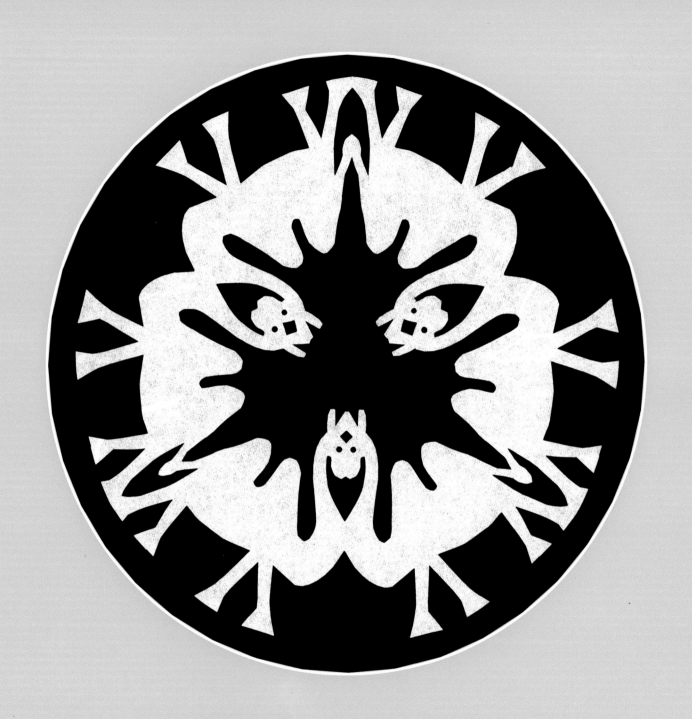

C IS FOR CAMEL

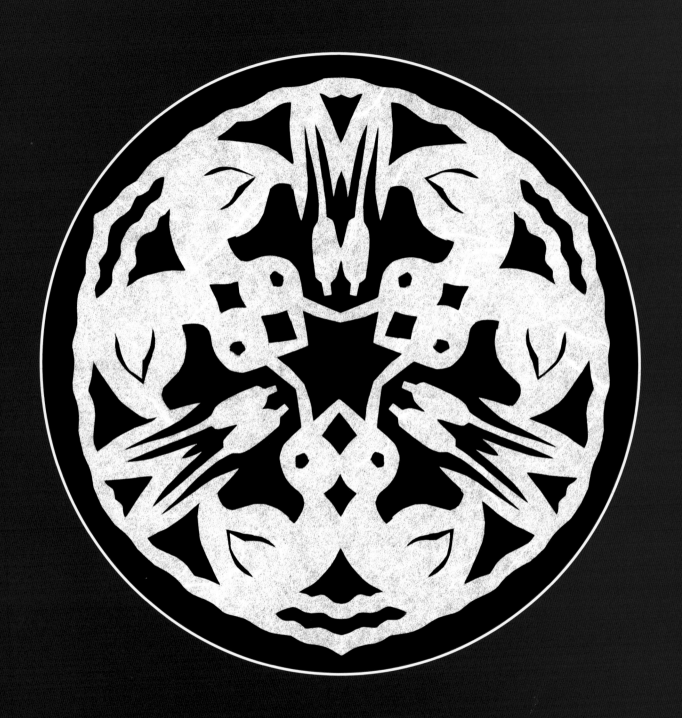

D is for DUCK

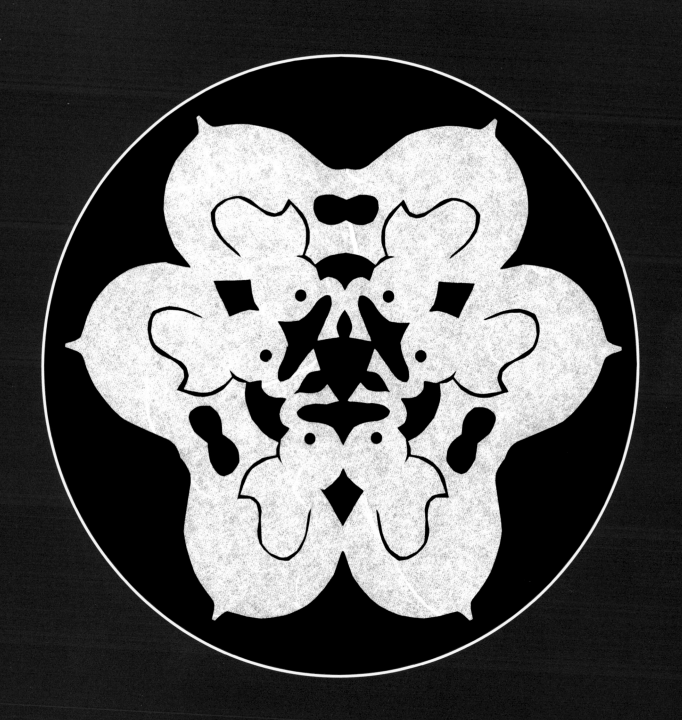

E IS FOR ELEPHANT

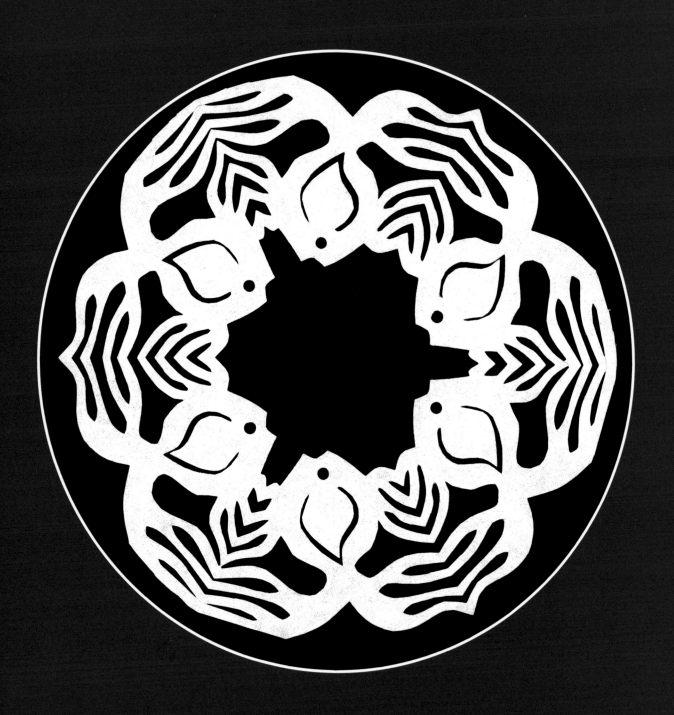

F IS FOR FISH

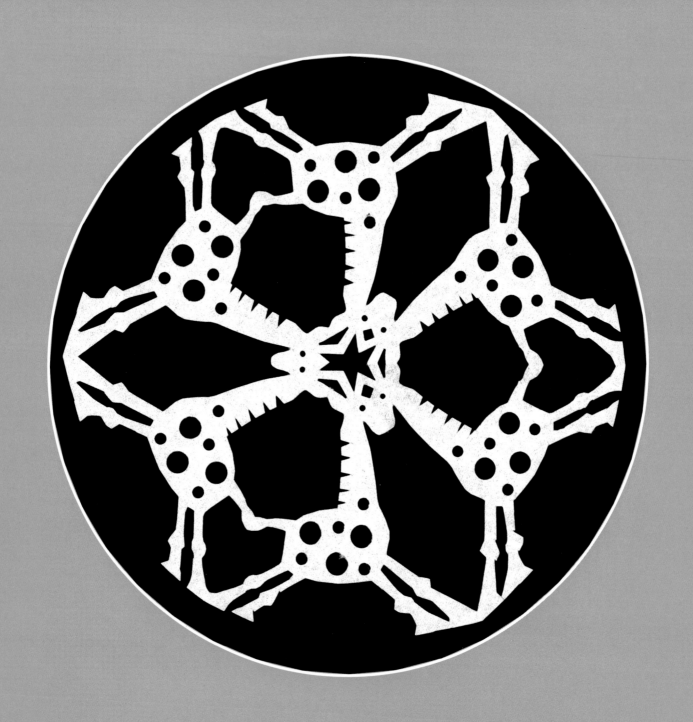

G IS FOR GIRAFFE

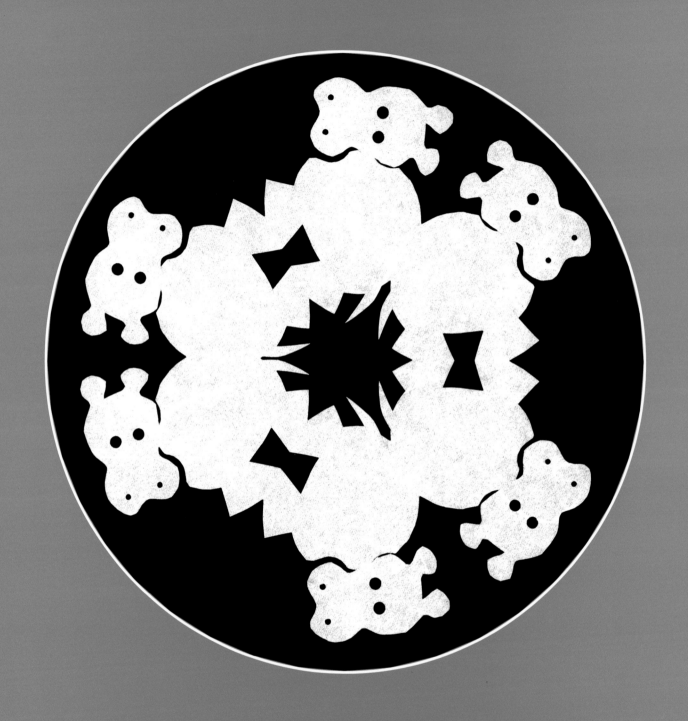

H IS FOR HIPPOPOTAMUS

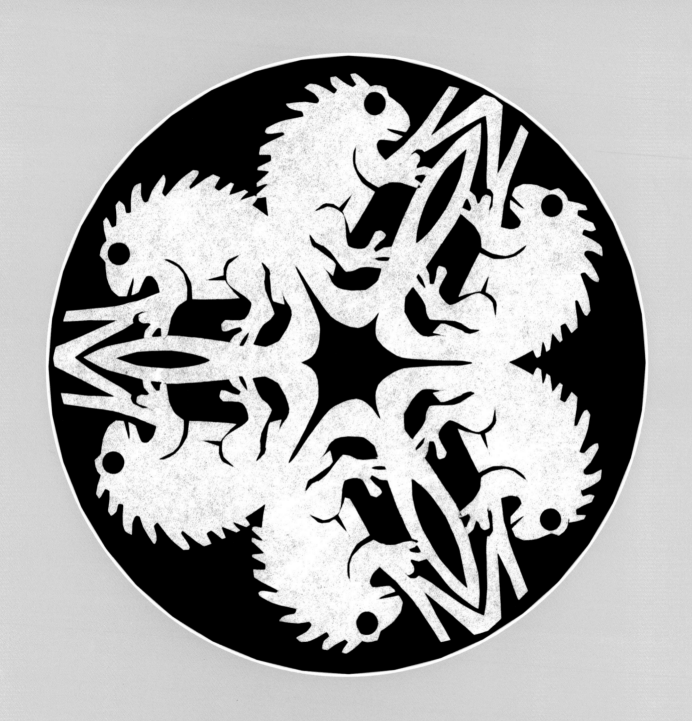

I IS FOR IGUANA

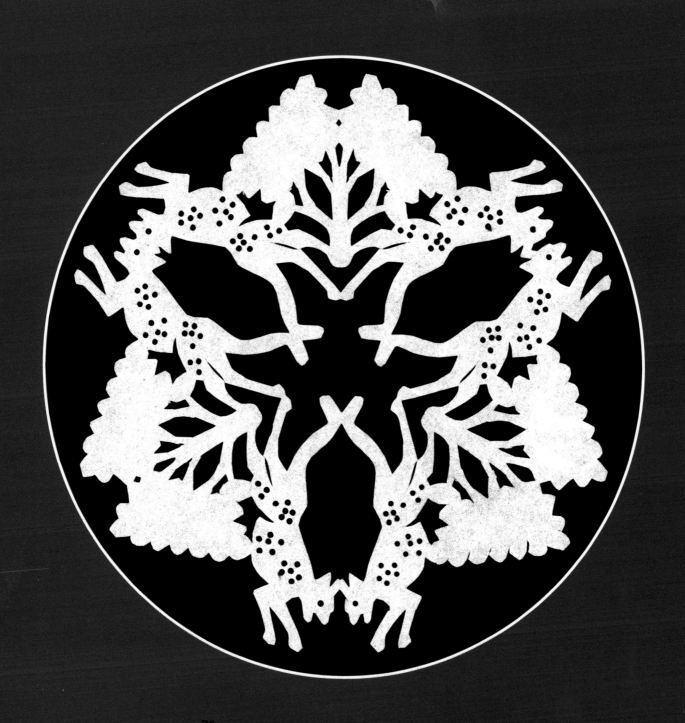

J is for JAGUAR

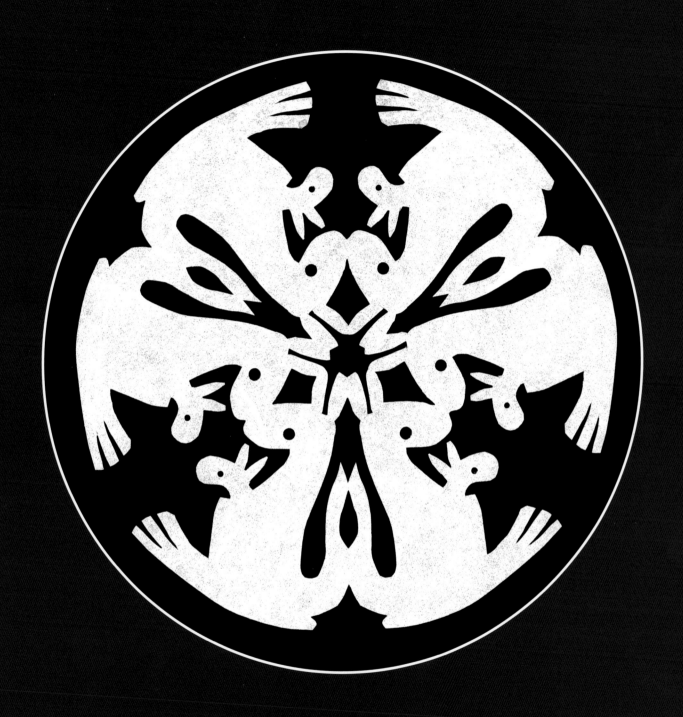

K IS FOR KANGAROO

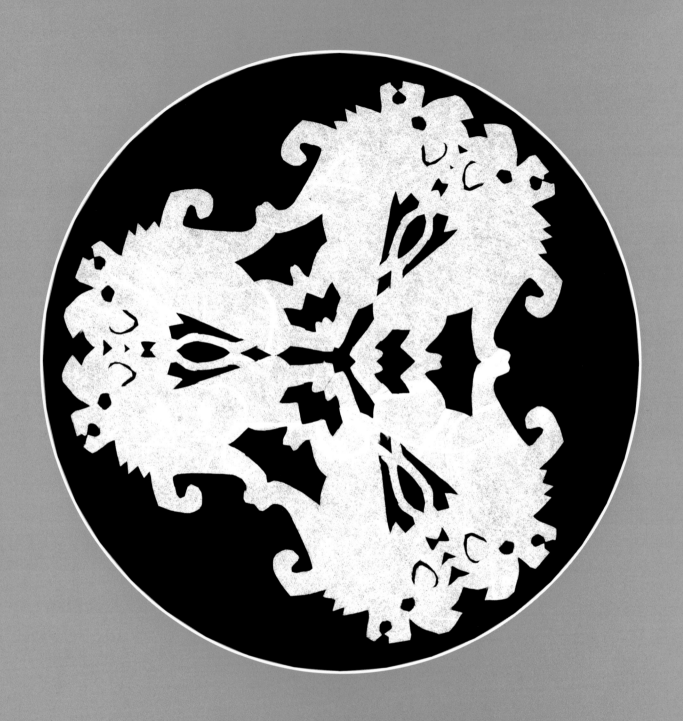

L is for LION

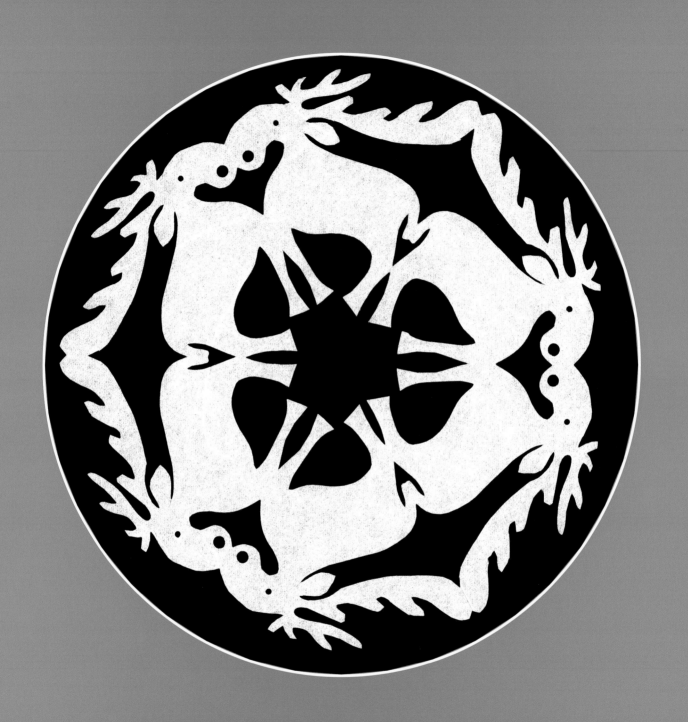

M IS FOR MOOSE

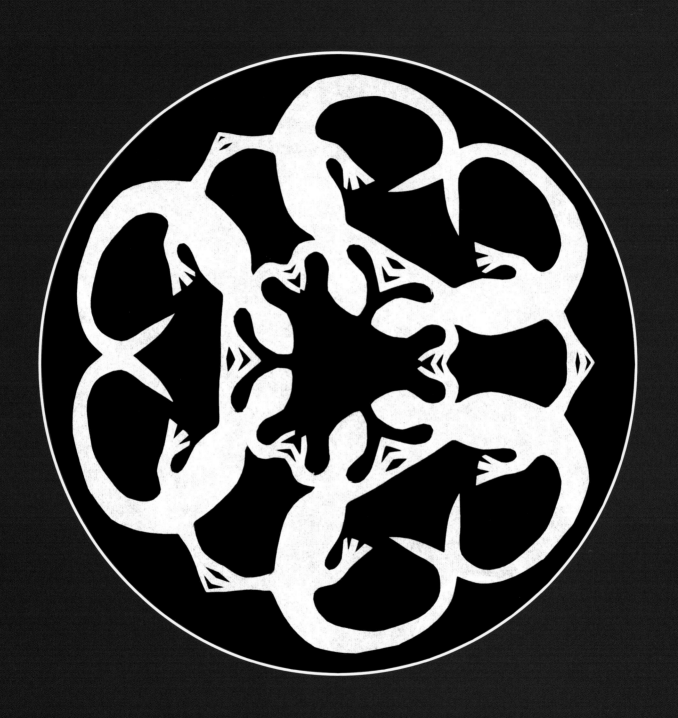

N IS FOR NEWT

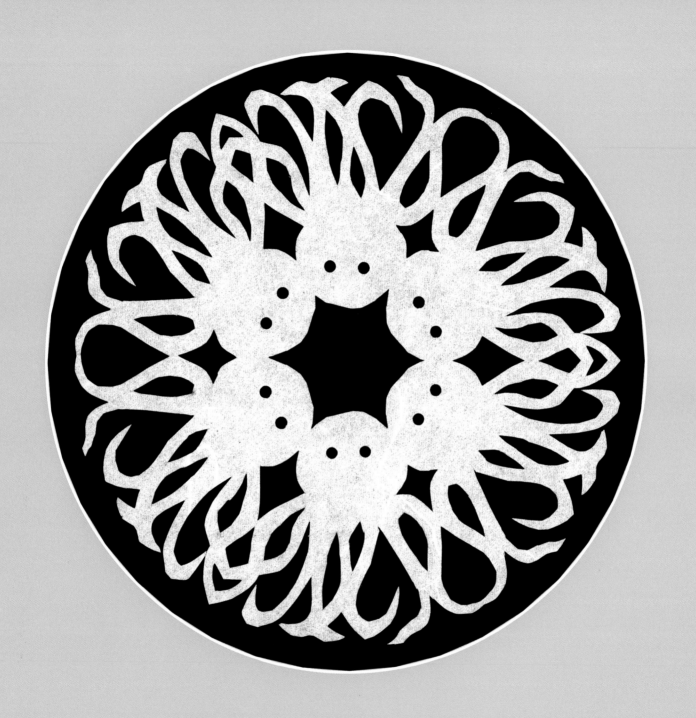

O IS FOR OCTOPUS

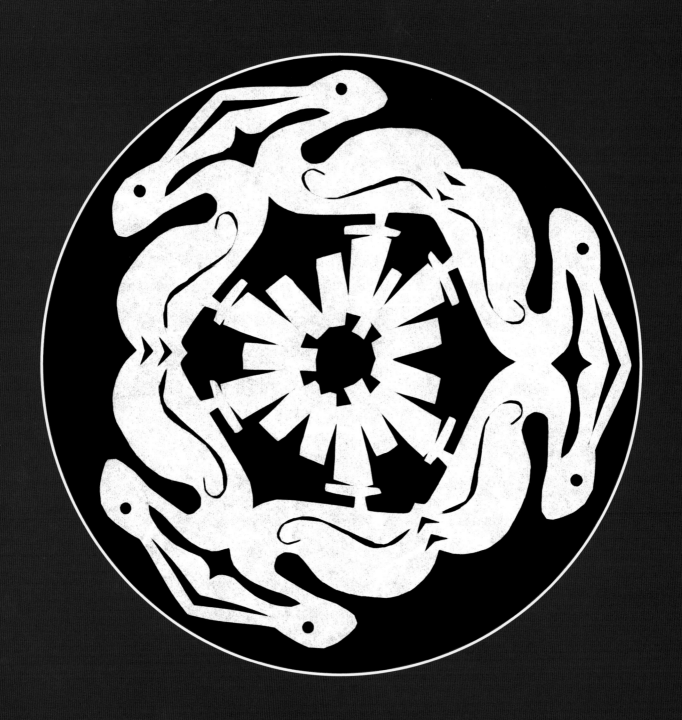

P IS FOR PELICAN

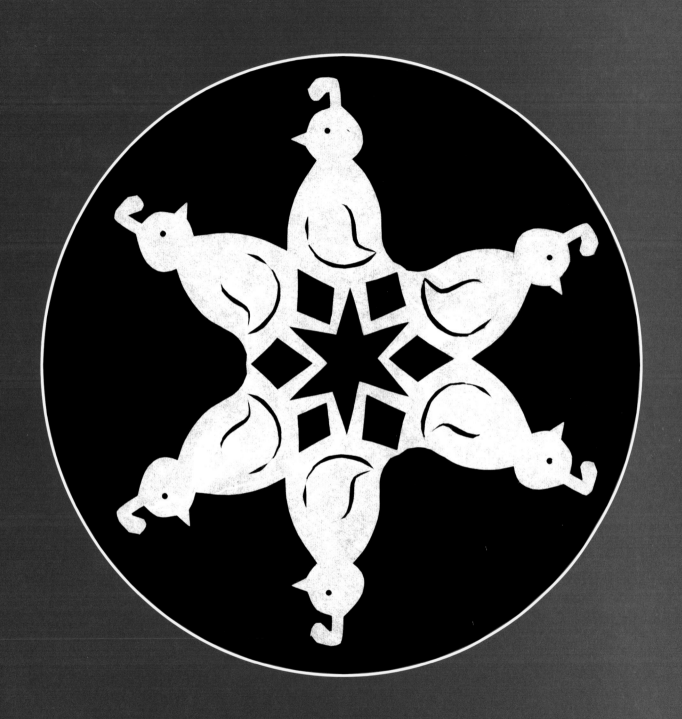

Q IS FOR QUAIL

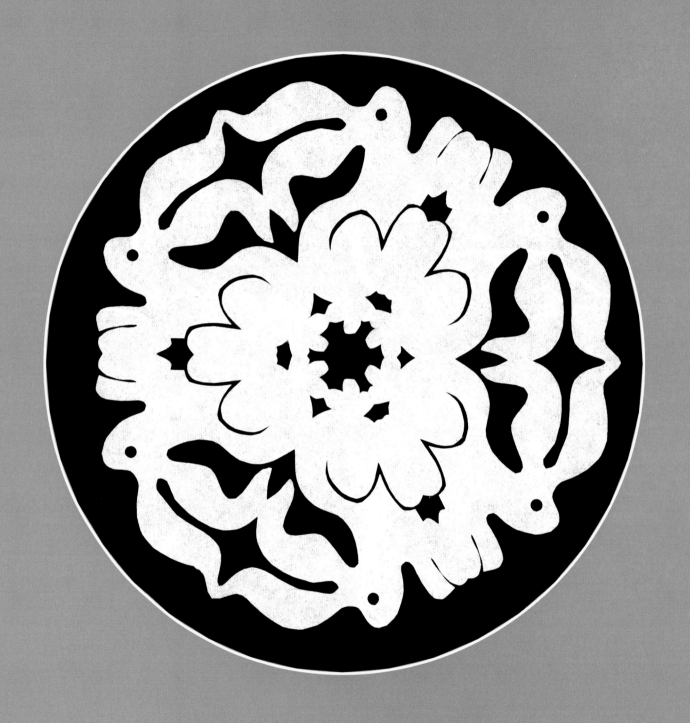

R IS FOR RABBIT

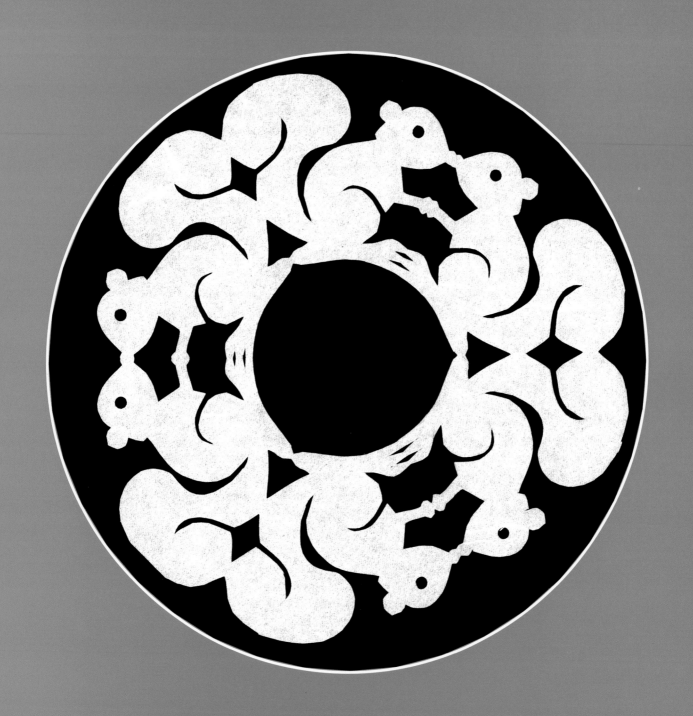

S IS FOR SQUIRREL

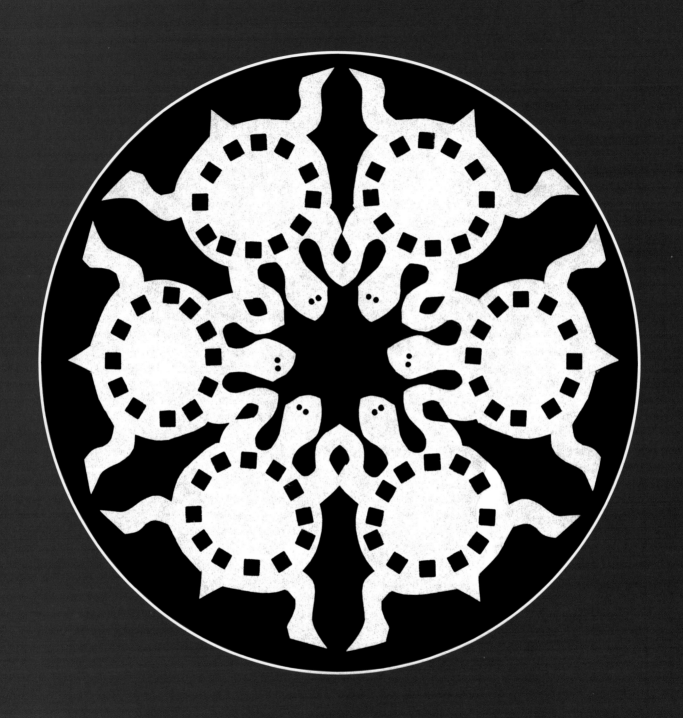

T IS FOR TURTLE

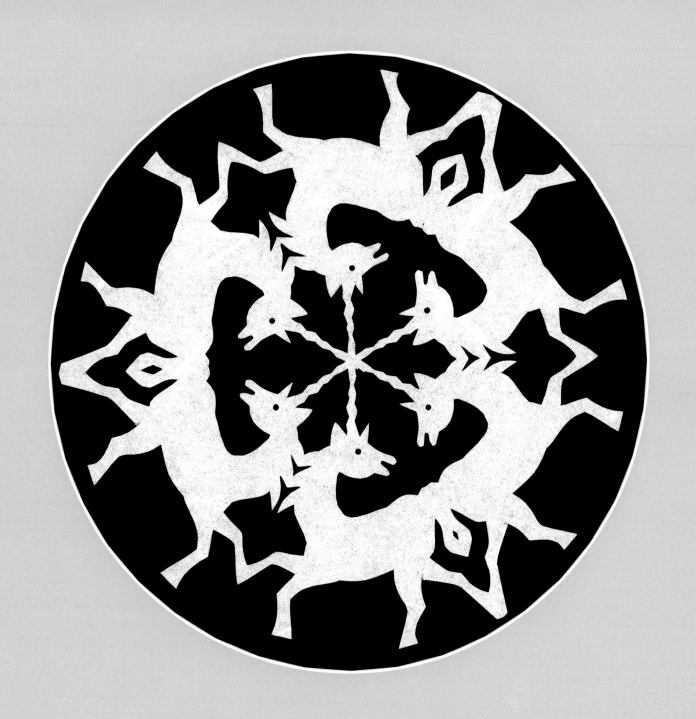

U IS FOR UNICORN

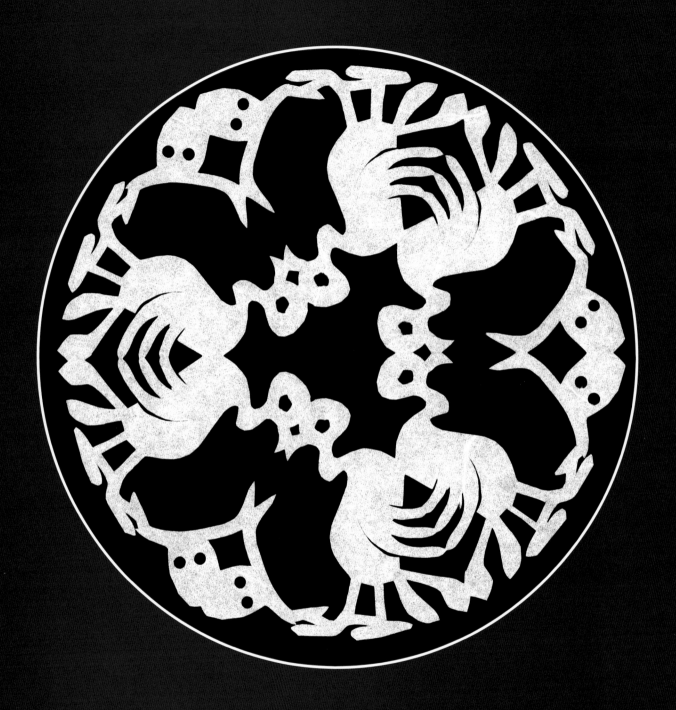

V IS FOR VULTURE

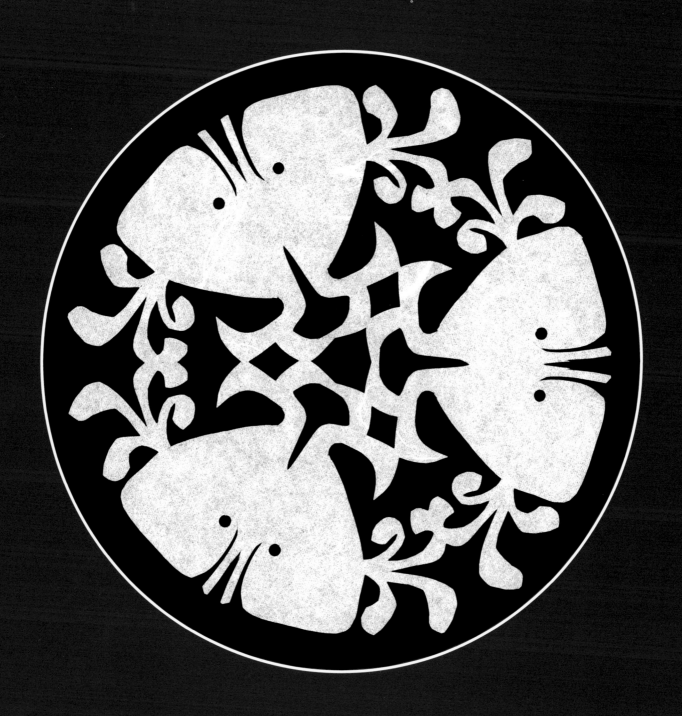

W is for WHALE

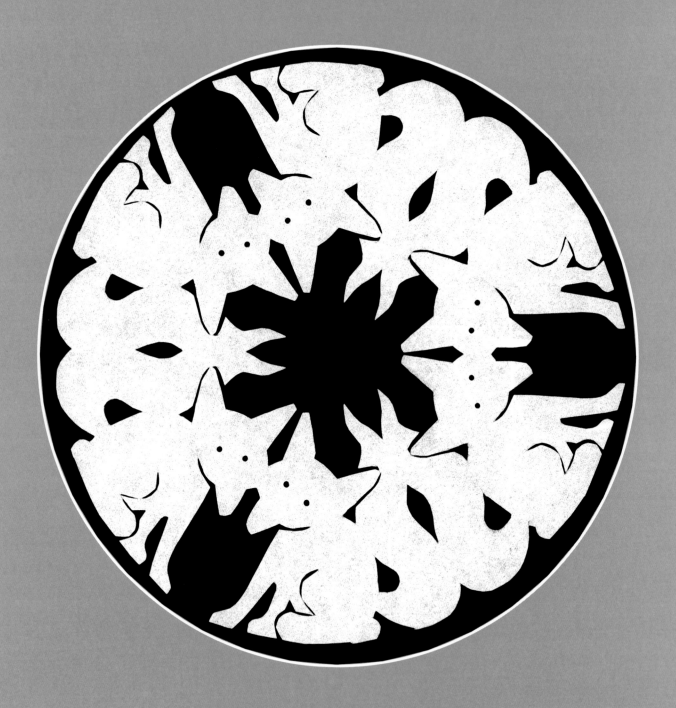

X IS FOR FOX

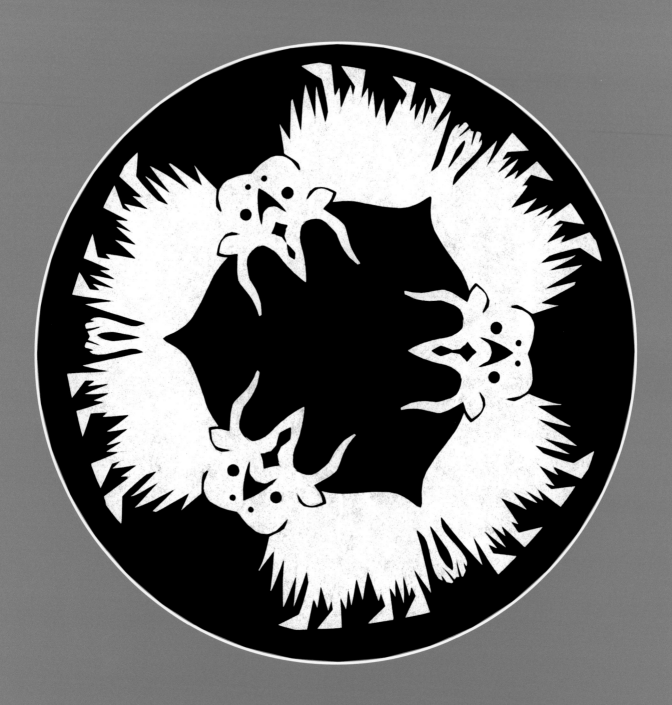

Y IS FOR YAK

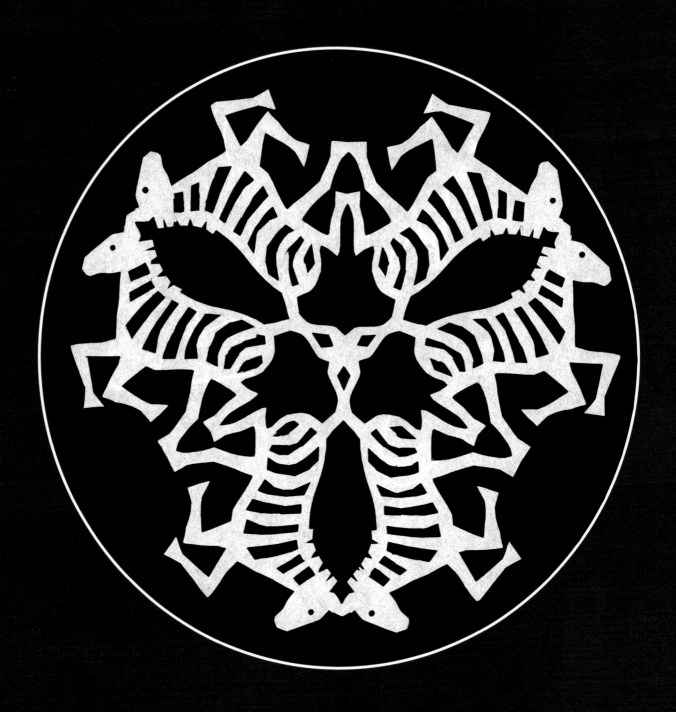

Z IS FOR ZEBRA

How to fold paper for a 6-sided Zooflake

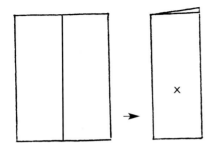

1. Fold a sheet of 8 1/2 x 11" paper in half lengthwise.

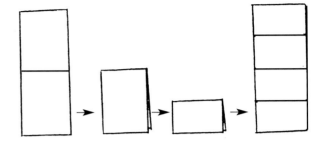

2. Fold that in half, then in half again (as shown). Then open it to position X (shown in step 1).

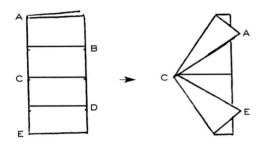

3. Fold side AC down through point B, and fold side CE up through point D (as shown). The corners A and E will stick out over the edge a bit.

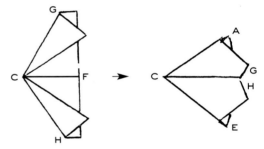

4. Fold side CG down to center (line CF), and fold side CH up to center (line CF) (as shown).

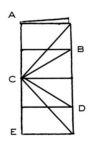

5. Open to position X (shown in step 1).

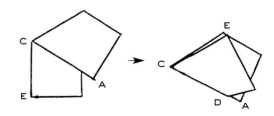

6. Refold like a fan, into thirds, by folding down along line CB and up along line CD (shown in step 5).

How to cut your Zooflake

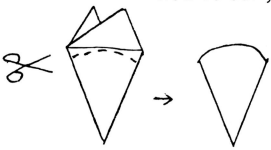

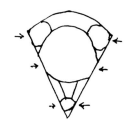

1. Flip the paper over and cut off excess corners (as shown) to create cone shape.

2. Draw a pattern on the cone. MAKE SURE that parts of design touch both folded sides.

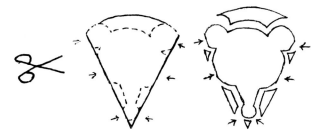

3. Cut around the outline. MAKE SURE to not cut folded edges completely off.

4. Use paper punches of various sizes to create details such as eyes.

5. Open it. Ta-da!

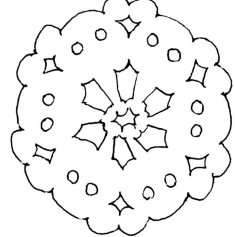

For Jan, Heidi, and Jon, who have always supplied the necessary ooh's and ah's to keep me going. —W. C. H.

First published in the United States of America in 2002 by Walker Publishing Company, Inc.

Published simultaneously in Canada by Fitzhenry and Whiteside, Markham, Ontario L3R 4T8

For information about permission to reproduce selections from this book, write to Permissions, Walker & Company, 435 Hudson Street, New York, New York 10014

Library of Congress Cataloging-in-Publication Data

Howell, Will C.
 Zooflakes / Will C. Howell.
 p.cm.
 Summary: Snowflake-style cutouts present a different animal for each letter of the alphabet. Includes instructions.
 ISBN 0-8027-8826-2 -- ISBN 0-8027-8827-0
 1. Paper work--Juvenile literature. 2. Animals in art--Juvenile literature. 3. English language--Alphabet--Juvenile literature. [1. Animals in art. 2. Alphabet. 3. Paper work.]
 I. Title.

TT870 .H67 2002
736'.98--dc21
[[E]] 2002066161

The artist used white Unryu rice paper, hand cut with scissors and assorted paper punches, to create the illustrations for this book.

Visit Walker & Company's Web site at www.walkerbooks.com

Book design by Maura Fadden Rosenthal/Mspace

Printed in Hong Kong

10 9 8 7 6 5 4 3 2 1

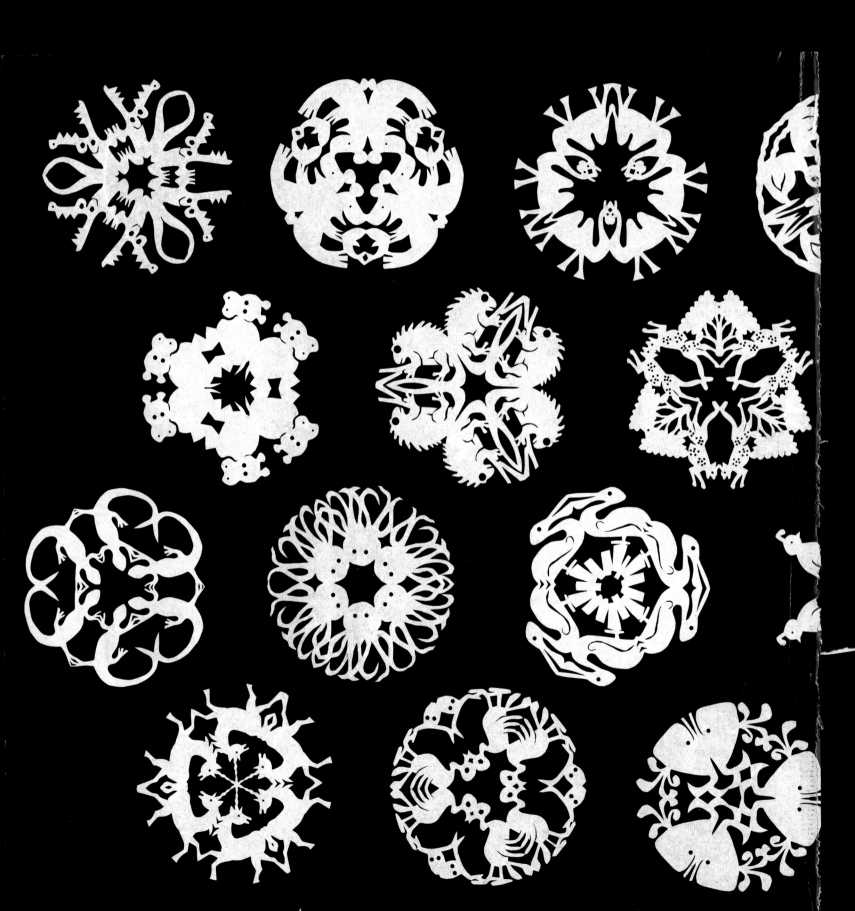